Zen
BIRDS

by Vanessa Sorensen

Adventure Publications
Cambridge, Minnesota

Acknowledgments

I would like to thank my mom and dad for all their love and support through the years. I would also like to thank all the crazy birders who have flitted in and out of my life. Observing you, and your tenacity, enthusiasm and sheer joy at the sight of birds, taught this mammalogist a deep love and appreciation for our feathered friends. I thank each and every one of you.

Cover design by Jonathan Norberg

Book design and illustrations by Vanessa Sorensen

10 9 8 7 6 5 4

Copyright 2010 by Vanessa Sorensen
Published by Adventure Publications
820 Cleveland Street South
Cambridge, Minnesota 55008
1-800-678-7006
www.adventurepublications.net
ISBN: 978-1-59193-272-7

To George

Scarlet cap and zebra coat
Such finery
For a carpenter

Red-bellied Woodpecker

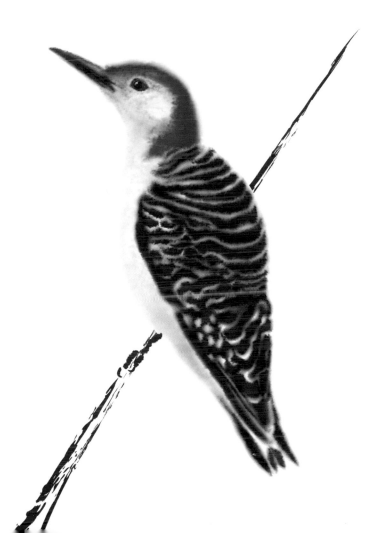

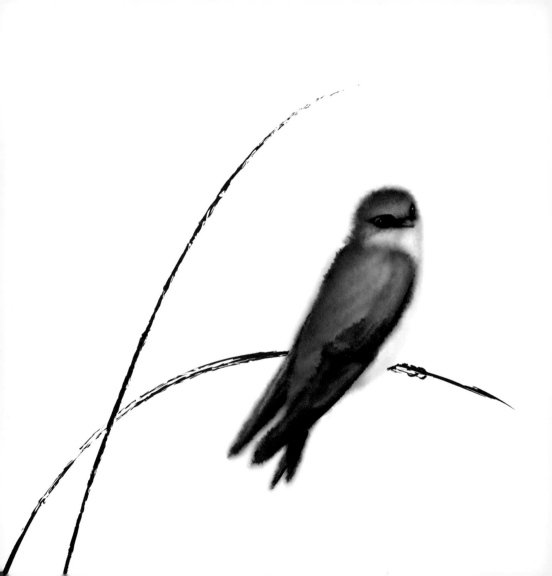

How lucky the air
To feel the graceful embrace
Of the swallow's wing

Tree Swallow

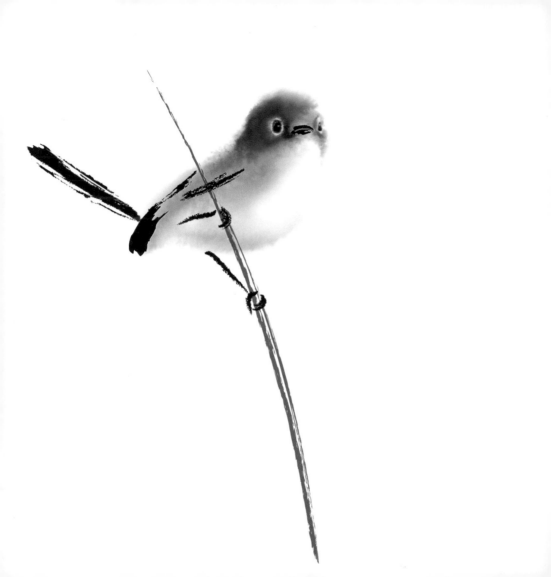

A blue-gray fairy arrives
Tail flitting
Spring will follow

Blue-gray Gnatcatcher

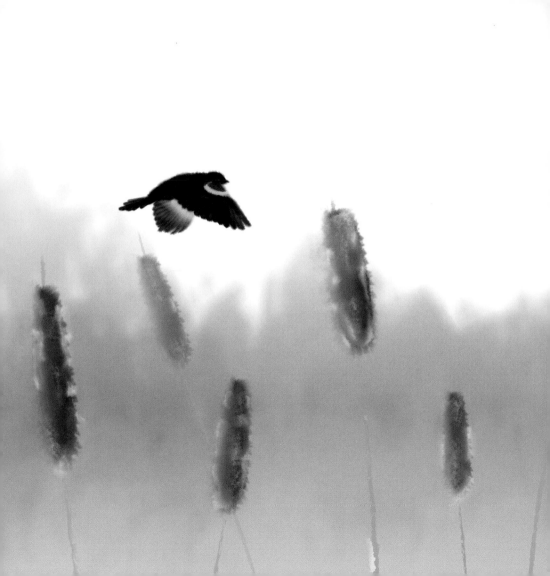

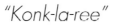

"Konk-la-ree"

A flash of scarlet and gold
How can she resist
The paramour of the marsh?

Red-winged Blackbird

Though temper and crest
May flare
Striking beauty

Blue Jay

Relentless vocalist
Must you practice
Under the moon?

Northern Mockingbird

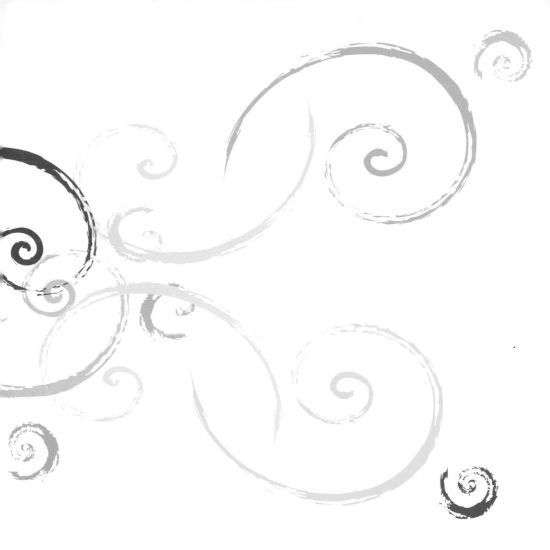

Oh tiny king
Who rules on high
Do flash your golden crown!

Golden-crowned Kinglet

To describe me
With just one color
Is a crime

Great Blue Heron

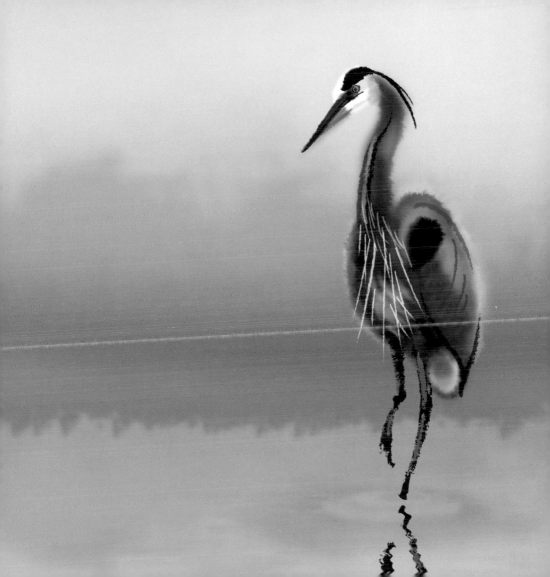

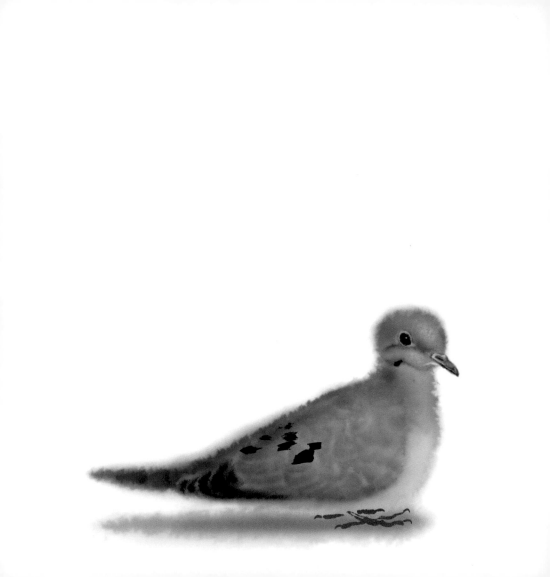

Cloudy sky
Mournful cooing
Rain is near

Mourning Dove

Social grace, elegant dress
Manners maketh man
And waxwing

Cedar Waxwing

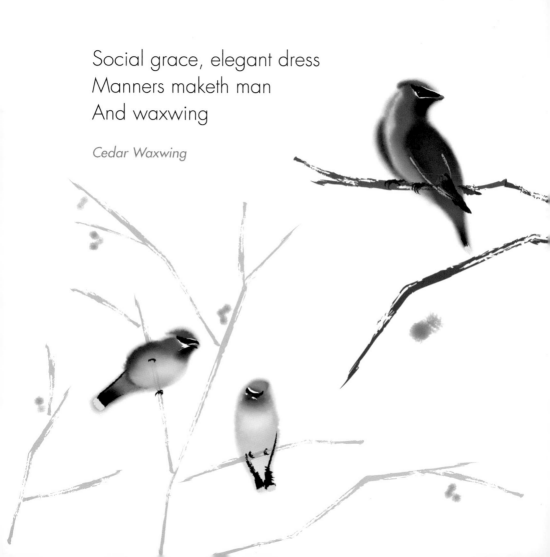

The master flutist
Joins the dawn chorus
Next performance dusk

Wood Thrush

Who watches the moon ascend?
Who awaits the cricket's call?
Who listens for the mouse's tread?

Great Horned Owl

His bill a spear
His crest electric
The wild king hunts

Belted Kingfisher

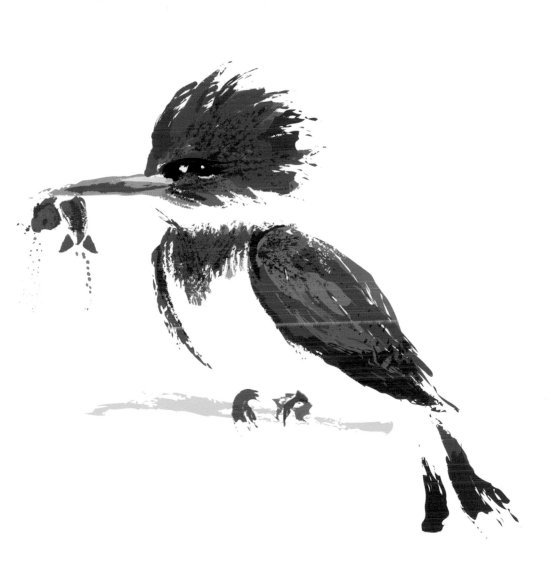

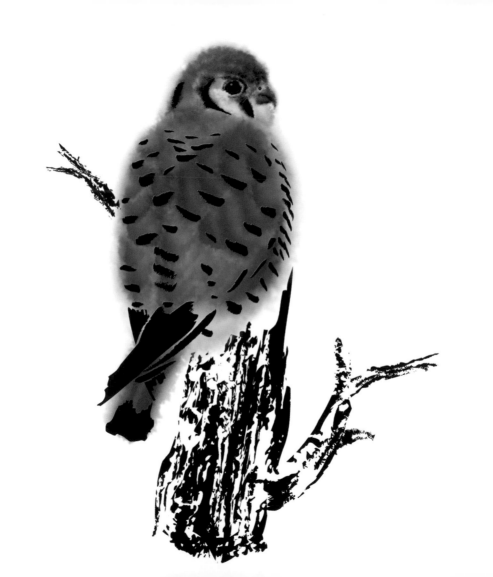

You ask
My favorite hobby?
Skydiving

American Kestrel

Ask the killdeer why
To feast on grubs in gravel
Such fancy attire?

Killdeer

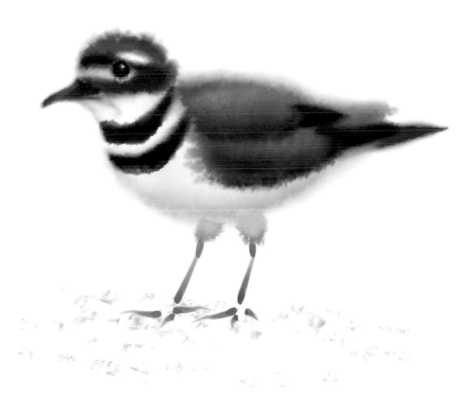

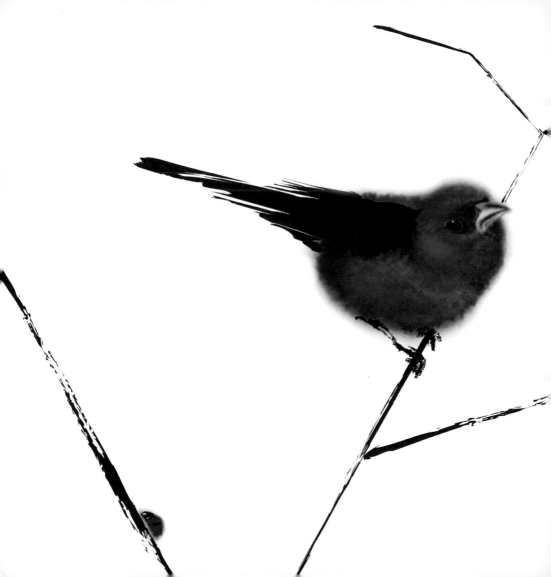

Ladybug's misfortune
The Tanager is quite fond
Of black and red

Scarlet Tanager

Your merry tin trumpets
And spiral, probing dance
Enchant me

Red-breasted Nuthatch

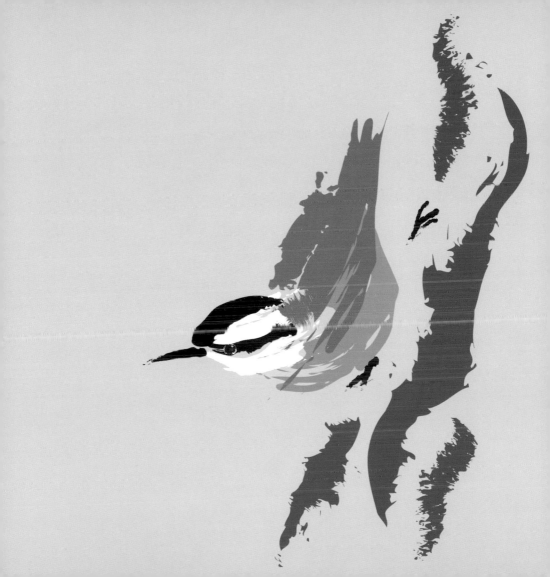

Orange from the sky
Orange on the ground
Orange delight!

Baltimore Oriole

I hear your call
And look all day
But cannot catch a glimpse

Yellow-billed Cuckoo

In the swamp
I spied a piece of gold
Singing *"Sweet, sweet, sweet, sweet, sweet"*

Prothonotary Warbler

Gaping mouths
And bulging eyes
Pop open and close

American Robin

It is the Robin
Who knows the value
Of a worm

American Robin

Lizards run
And mice be still
The butcher visits

Loggerhead Shrike (Butcherbird)

"Peter, Peter, Peter"

Crisp and clear
Your call pierces
The cold winter air

Tufted Titmouse

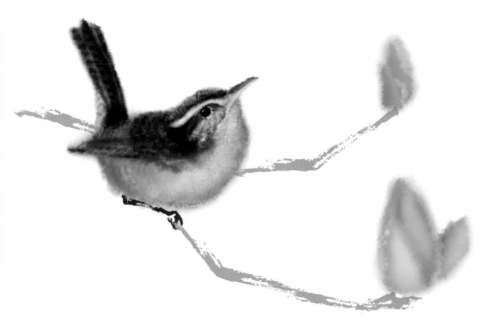

Energetic darting
Loud song
Tiny tyrant

Carolina Wren

"Drink your Tea-hee-hee-hee"

Your Constant Comment
Reminds Earl Gray
It's teatime

Rufous-sided Towhee

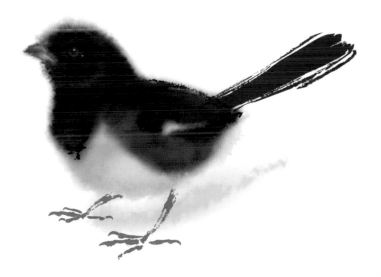

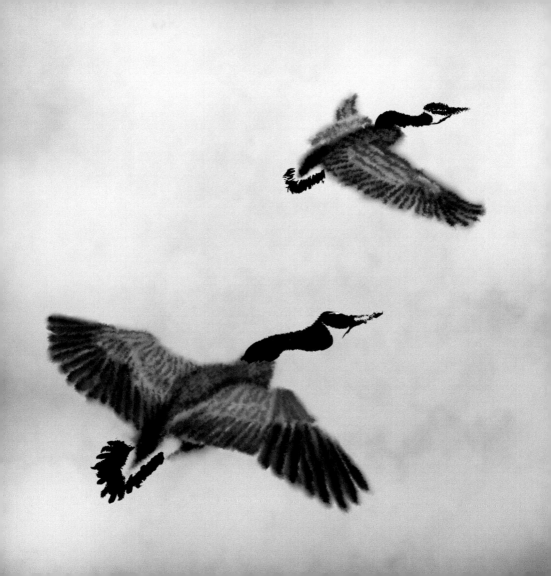

Heard from afar
I await
The flutter of your wings

Canada Goose

A kerchief in my pocket
A blue coat on my back
A black scarf round my famous throat
A girlfriend's all I lack!

Black-throated Blue Warbler

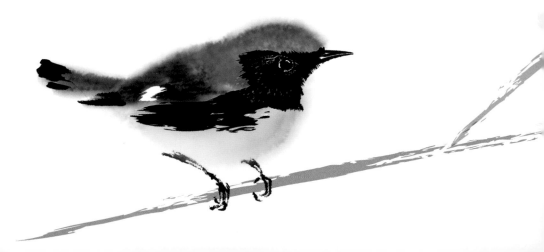

Deep in the undergrowth
A hooded wonder
Arresting all who spy him

Hooded Warbler

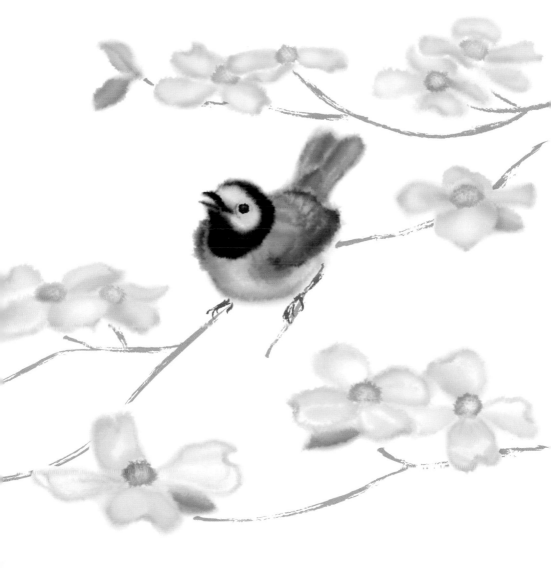

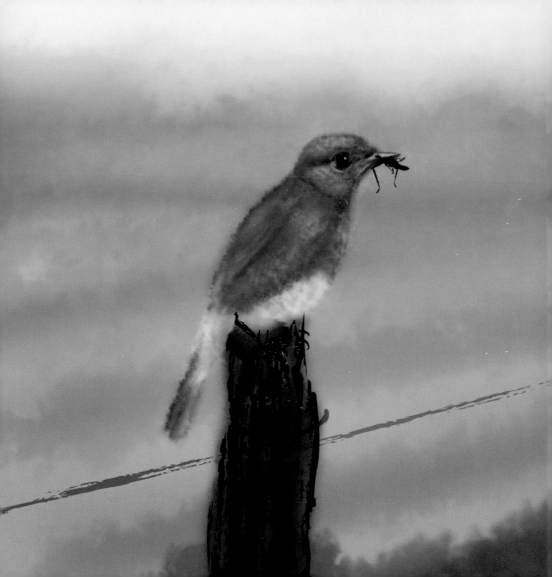

Freshly plowed field
Fine setting
For Bluebird breakfast

Eastern Bluebird

About the Author/Illustrator

Vanessa Sorensen is a graphic artist whose work is influenced by her training in zoology. Vanessa studied black bear behavior to obtain her master's degree. She then worked as an exhibit designer for the North Carolina Museum of Natural Sciences where she was able to combine her interests in science and art. This inspired her to return to school to study art and design. She is the author of *Zen Kitty* and is currently a freelance graphic designer and illustrator.

Birds have been a persistent and pervasive presence in Vanessa's life since her first ornithology class in college. Through years of living in the field and working at the museum, Vanessa learned the appearance, songs, behavior and habitat of many species of birds. She married an ornithologist, and the couple "nest" together in Ohio. His love of birds is contagious and a constant inspiration. Her affection for both (husband and birds) continues to grow through the years.